ENGLAND'S CATHEDRALS

IN WATERCOLOUR

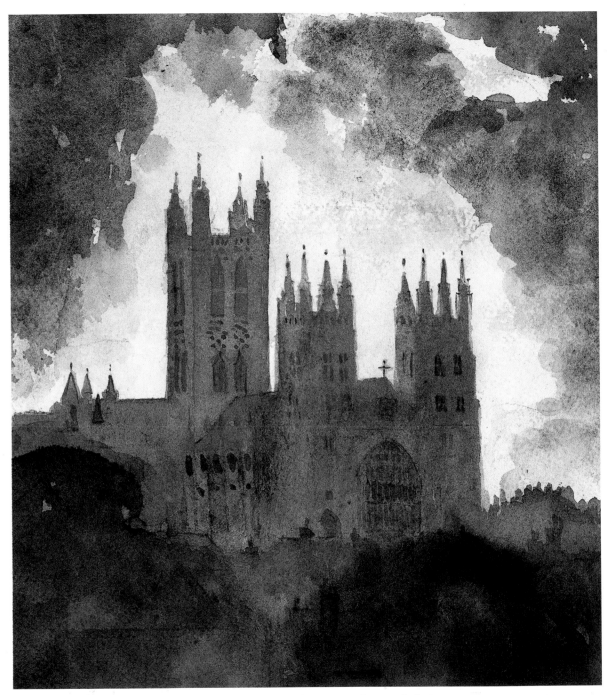

The dawning of Christianity. Canterbury Cathedral

ENGLAND'S CATHEDRALS

IN WATERCOLOUR

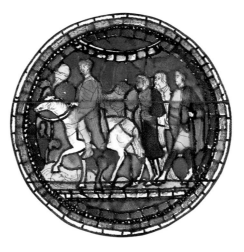

PETER HUME

FRIBA

LION

DEDICATION

This book is dedicated to the memory of my parents,
Grace and Frank Hume, and to my wife Sheila,
without whose help I could not have
completed this pilgrimage.

Copyright © 1999, 2006 Peter Hume
This edition copyright © 2006 Lion Hudson

The author asserts the moral right
to be identified as the author of this work

A Lion Book
an imprint of
Lion Hudson plc
Mayfield House, 256 Banbury Road,
Oxford OX2 7DH, England
www.lionhudson.com

ISBN 978 0 7459 5253 6
ISBN 0 7459 5253 4

First published in 1999
by Scala Publishers Ltd

This edition 2006
10 9 8 7 6 5 4 3 2 1 0

A catalogue record for this book is available
from the British Library

Typeset in Garamond
Printed and bound in Singapore

Title page: Thirteenth-century stained-glass roundel
showing pilgrims on their way to the shrine of
Thomas à Becket, Canterbury Cathedral

CONTENTS

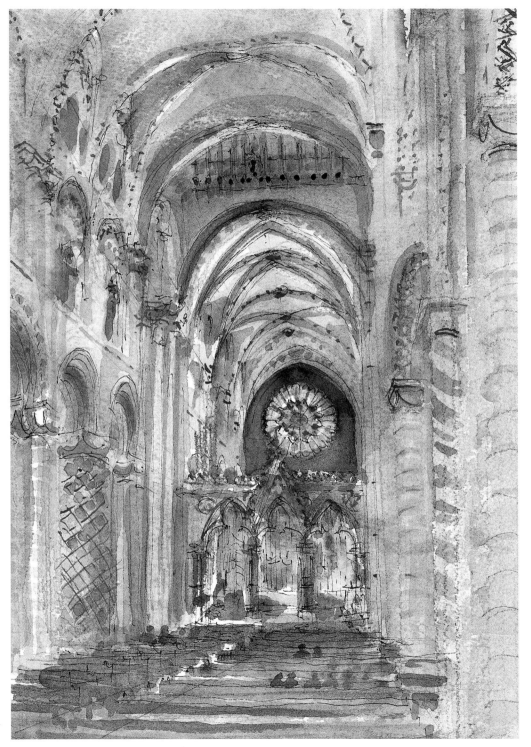

6

The nave looking towards the East Window. Durham Cathedral

FOREWORD

Architecture and the Fine Arts, including painting, were once seen as indivisible, not just by Michaelangelo and Bernini but more recently by Charles Rennie Macintosh and Le Corbusier (who was said to have organised his days so that he was an architect in the mornings and a painter in the afternoons). And there are many others: Piranesi drew fantastic imaginary architecture; today John Outram's buildings exhibit other-worldly decorative qualities; and such Cubist painters as Cézanne took a thoroughly architectural approach to painting.

Designing buildings involves the same issues as those that concern painters – composition, mass, space and form, colour, chiaroscuro, pattern, contrast and counterpoint, textures, rhythm, detail, the environment, and much more. There is, too, a shared desire to relate building, or the form of art, to context, to real life, and to be aware of people's concerns. I believe that all architects should be able to draw and paint. Surprisingly, not all can, and computer technology has not helped. As well as clarifying ideas, drawing is a visualisation process for the architect that heightens an awareness of space and form and many of the other issues I have mentioned.

However, the architect's knowledge of detail can become a hindrance for many of those who also paint. Their natural preoccupation with realistic form and detail is often their starting point. They must override these concerns in order to free their approach, to avoid the constraints of familiarity with the subject matter and their techniques of describing it. This is where Peter Hume's work succeeds. He has the true painter's ability to capture the spirit and mood of medieval cathedrals, buttressed by his architect's understanding of perspective and a building's structure, form and detail.

Our medieval cathedrals provide a rich tapestry of their history for all to see. I commend this book for showing us this rich-ness and for providing a fitting celebration of the millennium.

DAVID ROCK
President, Royal Institute of British Architects

PREFACE

The architect
Built his great heart into these sculptured stones,
And with him toiled his children, and their lives
were builded, with his own, into the walls.

HENRY LONGFELLOW (1807-82), PART 3 "IN THE CATHEDRAL", *THE GOLDEN LEGEND* (1851)

As an architect, I longed to see all the English medieval cathedrals, some of which were founded over a thousand years ago, and so far as I know no other artist has ever painted in watercolour all these buildings. At the approach of the second millennium it seemed an appropriate time to go on this architectural pilgrimage.

I set out on my journey around the country in 1996, and the more I saw and painted the more I was convinced that England possesses some of the greatest architectural treasures in the world, and that they should be seen, dreamed about and nurtured for future generations. I have tried to convey the spirit of each of these buildings, how they appeared to me in differing light conditions and my thoughts on seeing them, in some instances, for the first time.

The cathedrals are presented here in the order in which my journeys took place. The paintings were made on the spot, in the hope that my impressions will bring to my readers vivid memories of their own visits, or inspire them to go and see some, if not all, of these wonderful buildings. We must remember that they were not created specially as works of art, but that their genius of design and exquisite quality and craftsmanship were carried out for the glory of God.

Medieval cathedrals convey an evocative record of our nation's history. Here we see Saxon builders at work; the power of the Normans after the Conquest; the expression of new ideas arising from the Reformation; the destruction left by the Civil War; and the resurgence of religious life after the Restoration. Here too the prosperity and generosity of the Victorian restorers are visible, as are the scars and images of sacrifice caused by two world wars. Today, the modern enrichment of such artists as Chagall, Piper, Sutherland and Reyntiens brings the medieval cathedrals right up to the twenty-first century.

PETER HUME, *London*

LOCATIONS

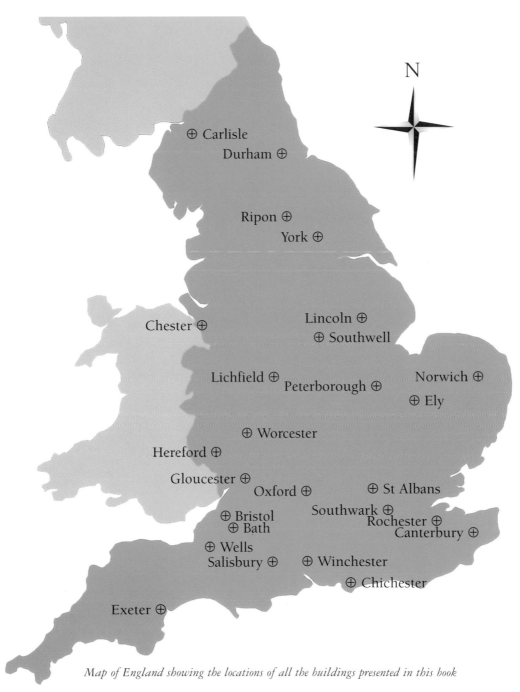

⊕ Carlisle
Durham ⊕

Ripon ⊕
York ⊕

Chester ⊕

Lincoln ⊕
⊕ Southwell

Lichfield ⊕
Peterborough ⊕
Norwich ⊕
⊕ Ely

⊕ Worcester
Hereford ⊕

Gloucester ⊕
Oxford ⊕
⊕ St Albans

⊕ Bristol
⊕ Bath
Southwark ⊕
Rochester ⊕
Canterbury ⊕

⊕ Wells
Salisbury ⊕
⊕ Winchester
⊕ Chichester

Exeter ⊕

Map of England showing the locations of all the buildings presented in this book

As I entered Christ Church Gate and caught the oblique view of the west front, with its elegant pinnacled towers and crocketed buttresses, and saw the beautiful central Bell Harry Tower, the unique status of this cathedral was immediately striking. This mighty cathedral, founded by St Augustine in 597, has a history that is an important part of our heritage. After several attempts at rebuilding, following disastrous fires, the present building – in Caen stone from Normandy – was begun in 1178, a few years after the murder in 1170 of Thomas à Becket in the north transept. To this cradle of Christianity in England, thousands of pilgrims came to worship at Becket's tomb; now they come to see a simple plaque in the pavement marking the spot where he fell.

Looking up the stately Perpendicular nave, through the archway of the choir screen, you can see the rising ascent to the high altar, an inspiringly spiritual effect, which is singular to Canterbury. Also unique are the stained-glass windows, the earliest

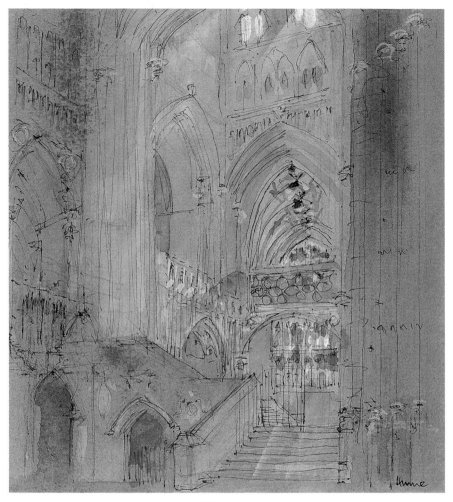

The martyr's corner

dating from the twelfth century. Their colour is deep and vibrant, giving a dramatic presentation of incidents from contemporary everyday life and stories from the Bible.

And specially from every shires ende
Of Engelonde to Canterbury they wende
The holy blisful martyr for to seeke
That them hath holpen whan that they were seeke.

GEOFFREY CHAUCER (1345-1400),
CANTERBURY TALES

C A N T E R B U R Y

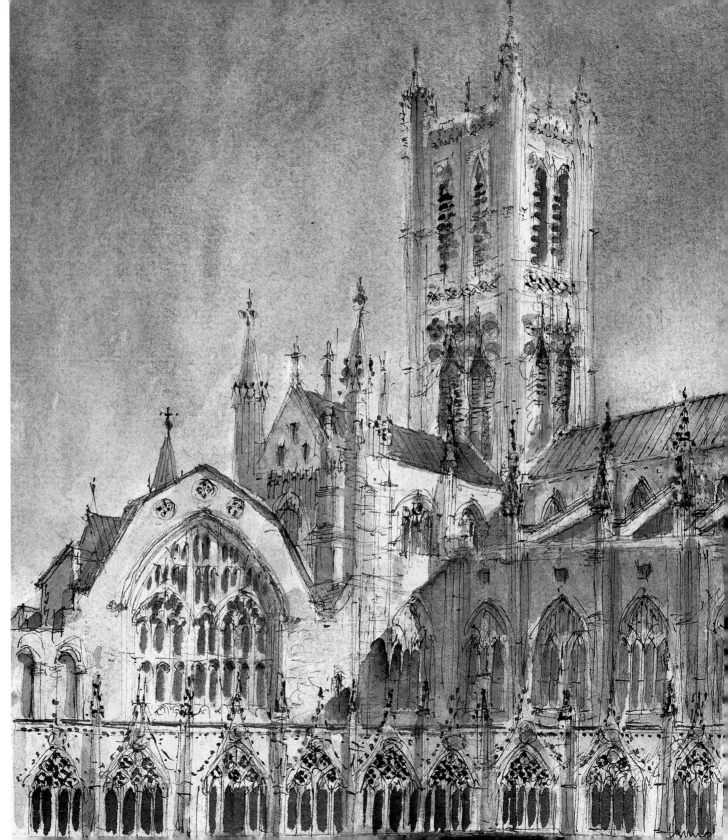

View from the cloisters with the Chapter House on the left

ounded by St Augustine, first Archbishop of Canterbury, in 604 as a cathedral near the River Medway, Rochester's original building was destroyed by the Danes and then rebuilt from 1080 to 1130. From the height of the grassy slopes of the castle I painted the Norman west front, a façade that is small in scale and gentle in mood, with especially fine carving of French influence in the doorway. In the thirteenth century this intimate cathedral, with its stately Norman nave, was the focus for hundreds of pilgrims who came to worship at the tomb of the martyr William of Perth. Their gifts swelled funds for lavish reconstruction of the choir and transepts in the Early English style. The central tower was rebuilt in 1905 and topped with an attractive and harmonious leaded, broached spire.

Charles Dickens (1812-70) was a regular visitor to Rochester, and he lived his last years here at his beloved home, Gad's Hill. The following passage from *Little Dorritt*, which describes the river at Twickenham, may well have been inspired by the view that Dickens would have seen of the banks of the Medway, from Rochester Bridge.

A tranquil summer sunset shone upon him as he approached the end of his walk, and passed through the meadows by the river side. He had that sense of peace, and of being lightened of a weight of care, which country quiet awakens in the breasts of dwellers in towns. Everything within his view was lovely and placid. The rich foliage of the trees, the luxuriant grass diversified with wild flowers, the little green islands in the river, the beds of rushes, the water-lilies floating on the surface of the stream ... were all expressive of rest.

CHARLES DICKENS, *LITTLE DORRIT* (1855-57)

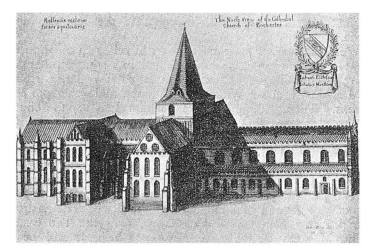

View of the north side in the seventeenth century, from an engraving by Daniel King

ROCHESTER

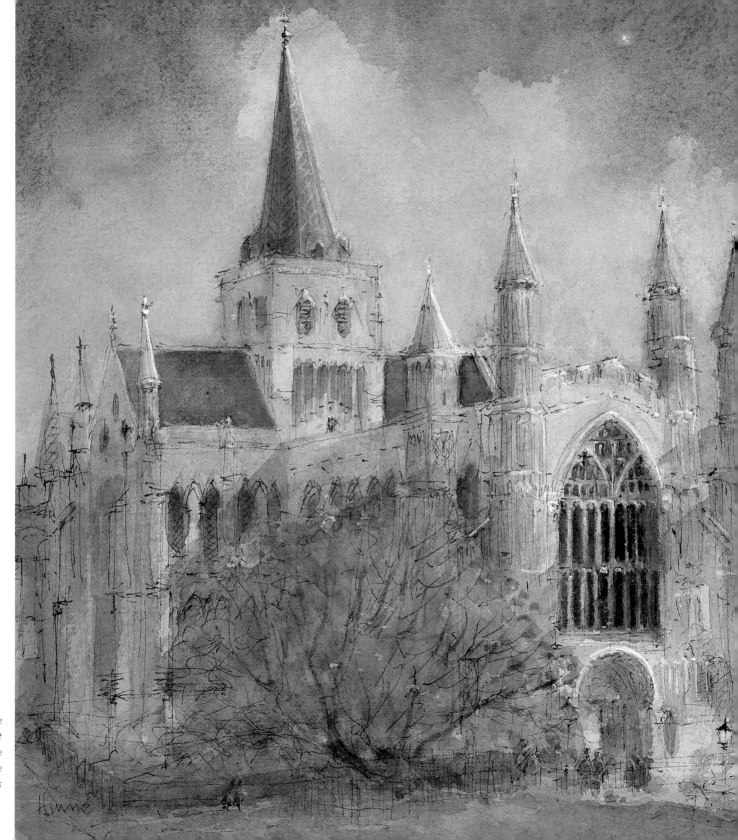

View of the
west front
from the
castle
grounds

Roman tiles in the nave of Southwark Cathedral are testament to the antiquity of the site, beside the River Thames by a ferry on which for centuries people entered and left London. Refounded in 1106, it was once a thriving cathedral with a rich history. Today only the eastern half is medieval and even that is incomplete because the east chapel was demolished for road widening. It became a cathedral in 1905, when the nave (which had been declared unsafe after years of neglect) was rebuilt, starting in 1890, in the Gothic style.

The exterior is hemmed in by twentieth-century commercial life, but the small adjoining garden is an oasis of peace. Southwark's elegant fifteenth-century tower with its tall, impressive pinnacles and chequered decoration, restored my spirits as I sketched.

Inside, the remaining gracious choir is a fine example of Early English architecture, and the Early English retro-choir is a worthy reminder of a well-proportioned Gothic design. In the south aisle there is a canopied memorial to William Shakespeare (1564-1616), who lived nearby. In *Richard II*, John of Gaunt speaks these lines:

This royal throne of Kings, this scepter'd isle,
This earth of majesty, this seat of Mars,
This other Eden, demi-paradise,
This fortress built by Nature for herself
Against infection and the hand of war,
This happy breed of men, this little world,
This precious stone set in a silver sea,
Which serves it in the office of a wall,
Or as a moat defensive to a house,
Against the envy of less happier lands.
This blessed plot, this earth, this realm,
this England...

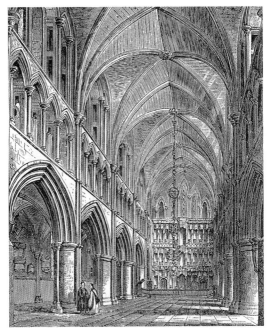

An engraving of the choir, reprinted in 1894

SOUTHWARK

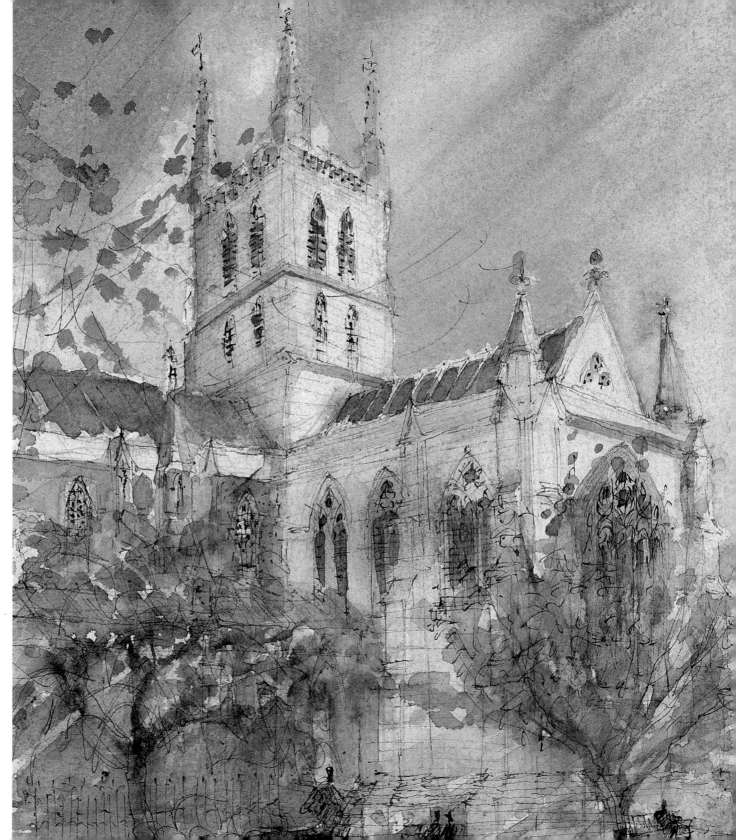

View of the tower from the south garden

The longest (at 556 feet) of all our medieval cathedrals, Winchester was founded before 650, but the present building was started in 1079. The fourteenth century witnessed a most splendid transformation with the rebuilding of the nave, which began in 1346. Later, the devastating consequences of the Black Death that hit the city account for the simpler west front, which has a more modest design than that of the splendid interior. Soaring Perpendicular stonework shafts in the nave (which were constructed to clad the Norman pillars, not to replace them), rise from the pavement to the intricate vaulting above, with its series of decorative bosses. The nave's huge height and length produce a vista of majestic proportions. In the north transept the pure, original Norman arches, unchanged for 800 years, evoke the spirit of a quite different period, as do fine medieval wall and roof paintings in the Chapel of the Holy Sepulchre.

In 1905 the east end of the building was found to be in danger of collapse. Originally the Normans had laid their foundations on water-logged ground and they had sunk into the soft, wet earth. Even after many years of underpinning, pumps were inadequate to rectify the moisture problem. A diver had to descend to the darkness under the peaty water, where he laid sacks of cement which were lowered down to him.

While he was staying at Winchester, John Keats (1795-1821) wrote one of his most famous poems:

Season of mist and mellow fruitfulness,
* Close bosom-friend of the maturing sun;*
Conspiring with him how to load and bless
* With fruit the vines that round the*
* thatch-eves run;*
To bend with apples the moss'd cottage trees,
* And fill all fruit with ripeness to the core;*
To swell the gourd, and plump the hazel shells
With a sweet kernel; to set budding more,
* And still more, later flowers for the bees,*
Until they think warm days will never cease,
* For Summer has o'er-brimm'd their clammy cells.*

"To Autumn" (1819)

The view from the north-west

WINCHESTER

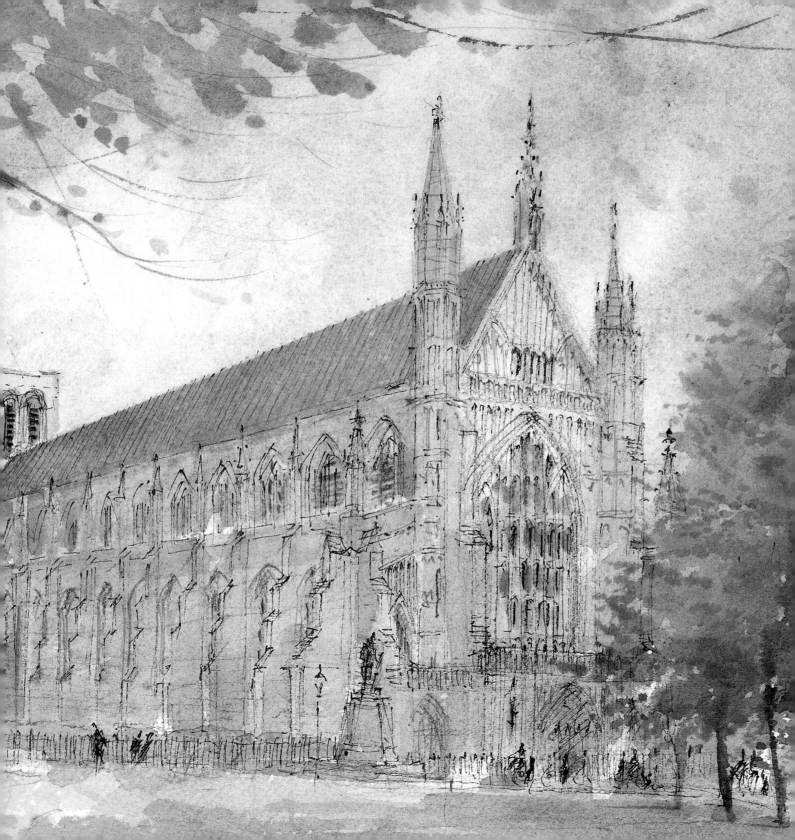

A Norman cathedral on a modest scale, Chichester was begun in 1075 and consecrated in 1184. The separate bell-tower is the original fifteenth-century structure, but the tower and elegant spire over the crossing are Victorian, restored after the originals fell in the great storm of 1861.

The simple splendour of the interior's Norman arches combines harmoniously with the elegance of the Transitional-style stone vaulting added later. The sombre stonework is enhanced by the tapestry by John Piper (1966) behind the altar, which gives singular colour and warmth to the east end of the cathedral. The enriching new works in Chichester do not seek to imitate the old. Chagall's glowing window in the north aisle of the presbytery is another exciting innovation. In contrast, a pair of relief sculptures in Purbeck stone dating from 1135, on the south aisle wall, depict Christ arriving in Bethany and the raising of Lazarus; these sculptures express the profound depths of human emotion.

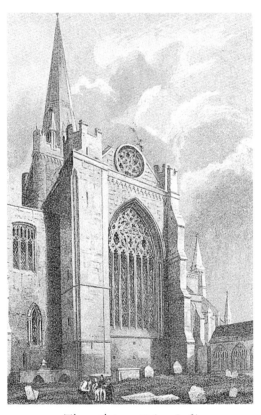

The south transept (c. 1836)

"On the fall of the tower and spire, February 21st 1861", a description of the dramatic event at Chichester cathedral, was written by Robert Willis (1800-77), Professor of Engineering, who witnessed the disaster.

On Thursday the 21st before daylight work was resumed. Seventy men working with commendable enthusiasm and courage, under great personal risk, made strenuous efforts to increase the number of shores under and around the tower ... By this time the continuous failing of the shores showed too plainly that the fall was inevitable ... Anxious groups outside the cathedral enclosure stood gazing at the tower and in less than half an hour the spire was seen to incline to the south west, and then to descend perpendicularly into the church, as one telescope tube slides into another, the mass of the tower crumbling beneath it. The fall was an affair of a few seconds and was completed at half past one.

FROM AN ESSAY BY ROBERT WILLIS, WRITTEN FOR THE ROYAL ARCHAELOGICAL INSTITUTE

CHICHESTER

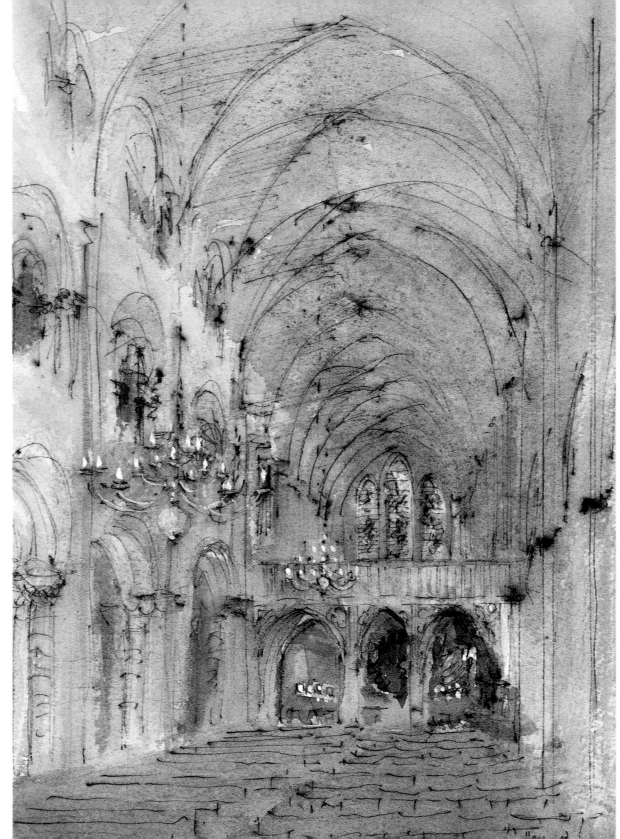

*View from
the nave
looking east*

19

Because Salisbury Cathedral was mostly built between 1220 and 1258, it has a unity of design within and without that is unique in England. It is dominated by the loftiest spire of the Middle Ages, at 404 feet high, and built around 1330 in the Decorated style, one hundred years later than the original crossing. With no added foundations, its huge weight caused the pillars and main walls to bow out, so that drastic reinforcing girders and strainer arches had to be introduced. You can see the added inverted arches in my painting.

One of my most vivid memories of the precise, orderly interior is of the vibrant blue east window, installed in 1980 and dedicated to Prisoners of Conscience. It is a glowing contrast to the cathedral's absence of colour, its pristine Chilmark stone punctuated by shafts of dark Purbeck marble.

Most of us are familiar with Constable's famous painting of Salisbury cathedral painted from the Bishop's Grounds, across the luxuriant water meadows.

In 1822 the bishop wrote to Constable:

"I was in hopes you would have taken another peep or two at the view of our Cathedral from my Garden near the Canal. But perhaps you retain enough of it in your memory to finish the Picture which I shall hope will be ready to grace my Drawing Room in London."
In reply Constable was afraid "it would not be a favourite there owing to a dark cloud – but we got over the difficulty".

REPRODUCED IN JOSEPH DARRACOTT, ENGLAND'S CONSTABLE (1985)

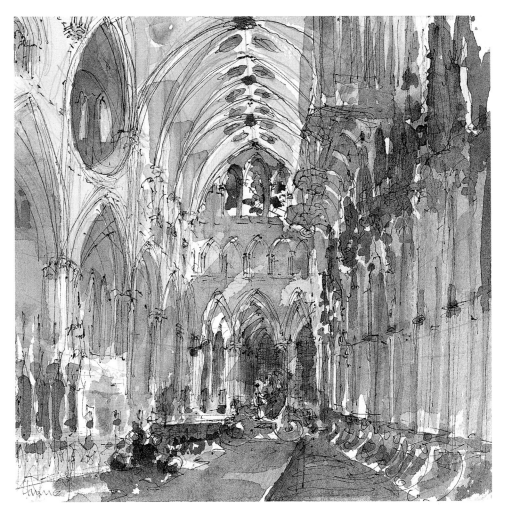

Interior view from the choir looking east

SALISBURY

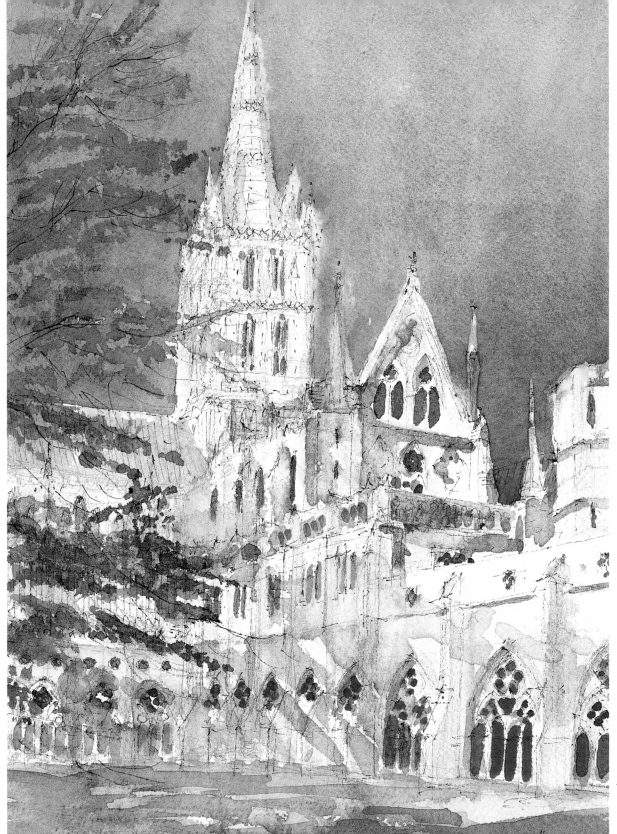

*View of the
spire from the
south cloister*

21

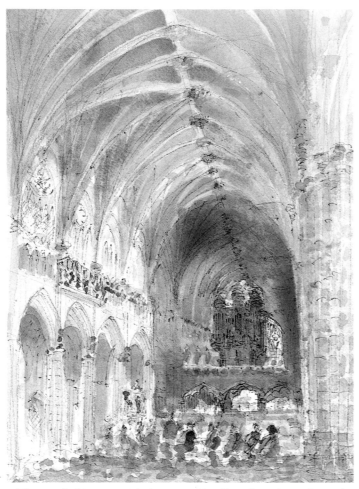

The nave looking east with the minstrels' gallery above the north arcade

King Canute rebuilt the Anglo Saxon minster here after it was destroyed by the Vikings, and it became established as a cathedral in 1050.

The west end façade, with its exhilarating shadow patterns, is intimate in scale and enriched by elaborate tiers of fourteenth-century sculpture. Rising above is a graceful late Decorated window, flanked by sloping gable ends, a golden, harmonious elevation with the original Norman towers of the transepts behind completing the composition.

The interior radiates a graceful, elegant beauty (despite the obtrusive organ), with its honey-coloured stone and pillars of slender, clustered shafts of blue Purbeck marble. Extending like an avenue of trees above the nave, choir and presbytery is the continuous "palm-ribbed" vaulted ceiling, 300 feet long, which is the longest, unbroken and probably finest Gothic vista in the world. Look out for an unusual feature: the fourteenth-century minstrels' gallery in the triforium on the north side of the nave.

The Exeter Book, a manuscript containing Old English poetry, was copied in about 940 and given to the cathedral by Bishop Leofric (d. 1072):

I have heard tell that there is far hence,
in Eastern parts a land most noble ...
On that grassy plain there standeth green,
decked gloriously, through power of the Holy One,
the fairest of all groves. The wood knoweth no breach
in all its beauty; holy fragrance resteth there
throughout that land; ne'er shall it be changed,
to all eternity ...

A bird of pinions strong, wondrously fair,
inhabiteth this wood; Phoenix it is hight.
The lonely bird holdeth its dwelling there,
its brave existence; ne'er shall death scathe it
in that winsome plain, while the world standeth.

"THE PHOENIX", FROM *THE EXETER BOOK*,
TRANS. ISRAEL GOLLANCZ (1895)

EXETER

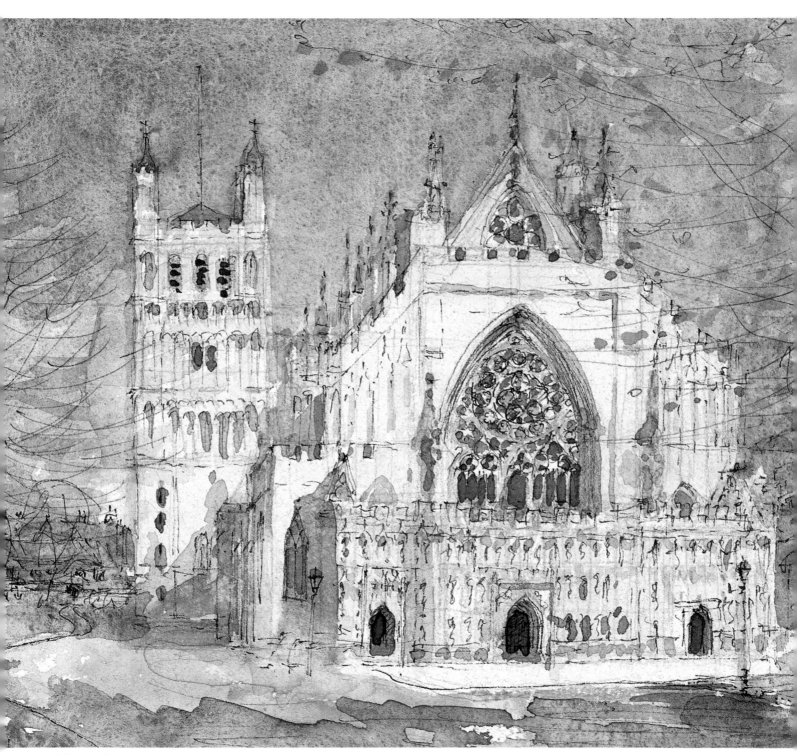

View of the west front

Wells is a truly English Gothic building in style and presence. It was founded in 909, but the present cathedral was begun in 1186. The west front, with far more original sculpture than any of our other cathedrals, is dramatic and impressive. A golden vision to look at and paint, in its limestone colouring the cathedral seems to change magically in differing light. The great weight of the noble fourteenth-century central tower, with finely carved pinnacles, had to be supported inside by unique buttressing "scissor arches", a visually sensational solution. These arches link the Early English nave arcade with the arching of the elegant painted vaulting, giving an aspect of fine proportion and space.

The capitals of the piers in the nave burst into lively carved foliage and humorous scenes of everyday life of the period – on one a boy has toothache, on another a man and his son steal fruit. We are taken back in time also by the "heavenly stairs" approaching the fourteenth-century Chapter House, mysterious and worn by so many footsteps over the centuries.

Wells's own Bishop Ken (1637-1711) wrote this well-known hymn:

Praise God from whom all blessings flow,
Praise him all creatures here below,
Praise him above, ye heavenly host,
Praise Father, Son and Holy Ghost.
No. 45, *SONGS OF PRAISE*

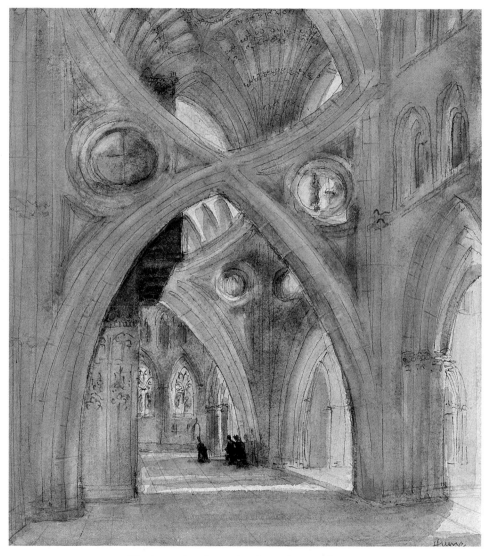

The inverted arches used to brace the central tower

WELLS

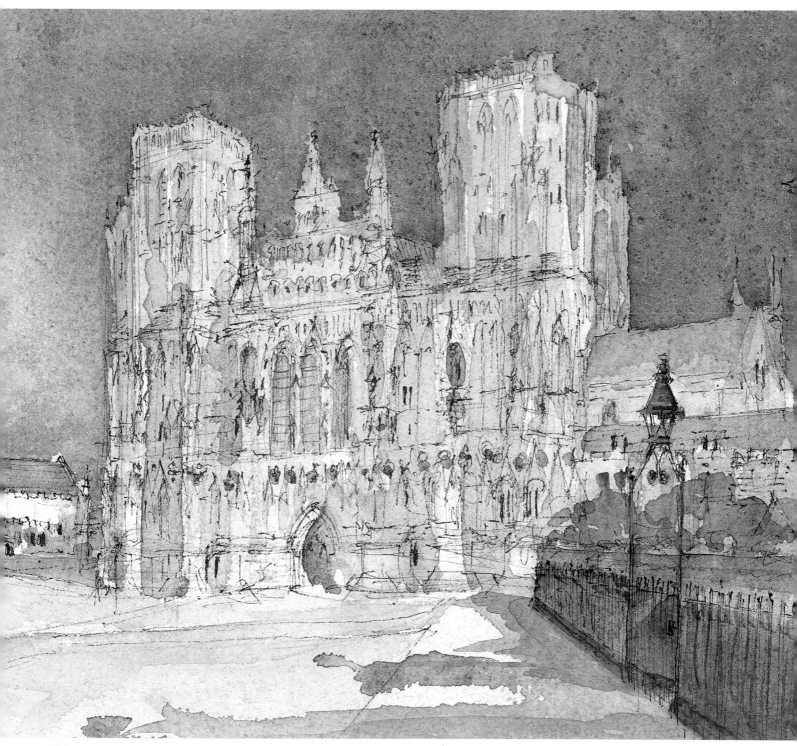

View of the west front

Bath Abbey has been a parish church for over 600 years and is no longer a cathedral, but because it is part of the see of Bath and Wells I included it in my pilgrimage.

The present building stands upon the site of the great Norman church, founded as a cathedral in 1107, the nave of which was longer than the whole abbey today. Sadly, by the thirteenth century it had fallen into ruin. The towers adjoining the west façade present a unique feature, the sculpture upon the faces telling the story of a dream by Bishop King. Being greatly distressed by the state of the old cathedral, he dreamed of angels ascending and descending a ladder to heaven. A voice implored "a king to restore the church", and he believed it was a personal message from God. In 1499 he began to rebuild the abbey on a much smaller scale, in the latest Perpendicular style. But it fell victim to the ravages of the dissolution of the monasteries and was plundered.

Bath Abbey is called the "Lantern of of the West". Slender white piers and soaring, delicate fan vaulting inside are illuminated through huge areas of glass on all sides, and particularly through the great east window, a crystal tapestry of Bible stories. My only reservations about this beautiful church are perhaps prompted by the almost new appearance of the nave, which was completed in the nineteenth century.

During Gilbert Scott's restoration, begun in 1860, the numerous memorial tablets (more than in any other church except Westminster Abbey) were removed from the pillars and re-erected on the walls, row upon row. They have always excited interest, and Samuel Pepys (1633-1703) recorded that he liked "going to look over the memorials because they provide a visual history of the English people".

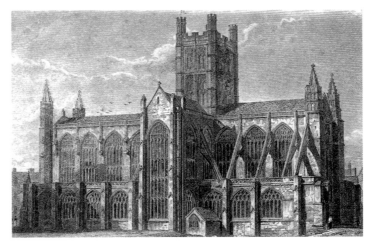

The south side of the cathedral, from an engraving by J. Lewis (c. 1825)

BATH

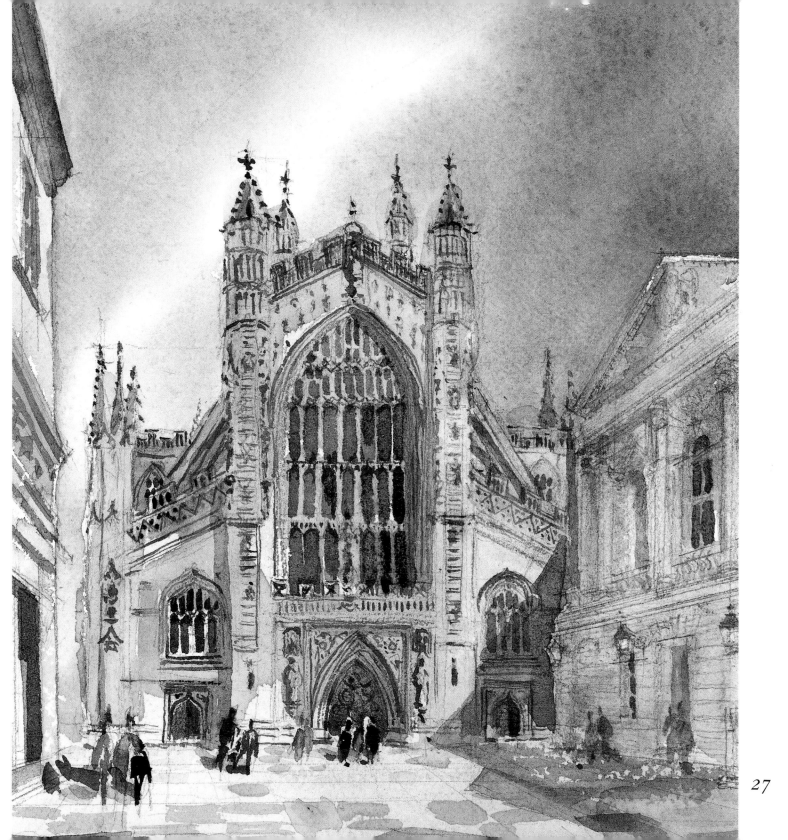

27

There is a rewarding view of Bristol Cathedral from the south garden, where I could look up at the lovely fifteenth-century central tower and the original Norman Chapter House. An Augustinian monastery was established here in 1140, and the abbey was given cathedral status by Henry VIII in 1542. The exterior was restored in the nineteenth century.

The nave, the erection of which was abandoned during the Reformation, was rebuilt by G.E. Street in the nineteenth century in harmony with the medieval choir started in 1298. Bristol Cathedral is the only example in England of a hall-church, in that the roof vaulting of the nave, aisles, choir and Lady Chapel beyond, is at the same height, and is supported by the tallest arches in England. This unusual construction gives a calm, light and dignified interior, and permits you to see the entire length of the cathedral, with its elegant vaulting, lit by the immensely tall aisle windows. Particularly fine and unusual are the kite patterns of the lierne vaulting in the choir, erected about 1300.

Bristol was one of my happy discoveries. I was particularly impressed with the simple ornamentation of interlacing arches and geometric designs in the rectangular, late Norman Chapter House.

On the high altar are two historic, silver candlesticks, thanksgiving gifts for the safe return of two small ships, *The Duke* and *The Duchess*, in 1709. These ships had sailed round the world and had brought back from the Pacific Ocean Alexander Selkirk whom they had rescued from the Juan Fernandez Islands. Daniel Defoe based his book *Robinson Crusoe* on Selkirk's adventures.

View of the north-east, from St Augustine's Green (c. 1864)

BRISTOL

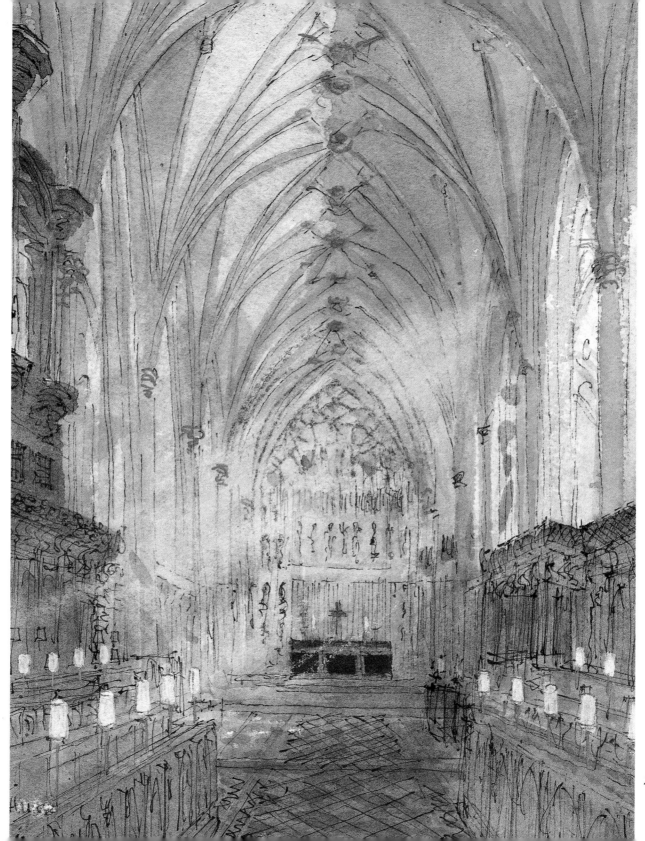

*View from the
choir looking
towards the
east window*

29

Glorious Gloucester, seen for the first time, is unforgettable; I painted it while the sun shone on its elegant, lace-like stone detailing. The tower, the richly carved porch and the whole length of the building are enhanced by a unity of intricate tracery that conveys a spirit of lightness and grace. In this cathedral is found the earliest instance of the very English Perpendicular style in a delicate, cream-coloured stone. St Peter's monastery was founded here in 681 and the church became a cathedral in 1541.

The interior's bold cylindrical pillars of the nave, which are unadorned Norman, are a striking contrast to the lofty choir and transepts, remodelled in 1340, with clustered shafts and rich Perpendicular tracery embroidered over the earlier Norman vaults. Beyond is the Great East Window, one of the largest in England and the glory of the cathedral, with superb fourteenth-century glass commemorating the fallen at the battle of Crécy (1346). I was equally impressed by the small contemporary window designed by Thomas Denny, a symbolic vision in blue, in the south ambulatory chapel.

I ended my day's pilgrimage here painting in the fan-vaulted fourteenth-century cloisters, which are like an avenue of giant ferns.

On the west wall of the nave is a memorial plaque to Sir Hubert Parry (1848-1918); a composer who is known for his setting of the hymn *Jerusalem*, based on Blake's poem *Milton*.

Bring me my Bow of burning gold;
Bring me my Arrows of desire
Bring me my Spear: O clouds unfold!
Bring me my Chariot of fire.
I will not cease from Mental Fight,
Nor shall my sword sleep in my hand
Till we have built Jerusalem
In England's green and pleasant land.

WILLIAM BLAKE, FROM THE PREFACE TO *MILTON* (1804-10)

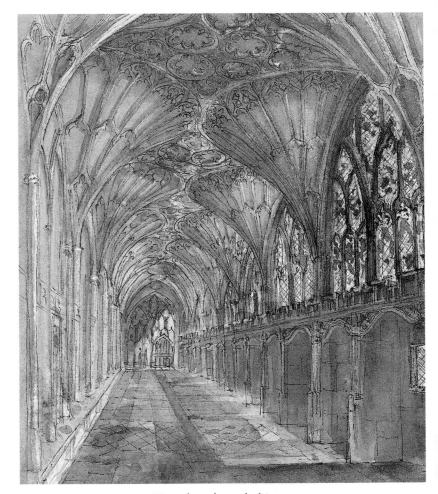

View along the south cloister

GLOUCESTER

30

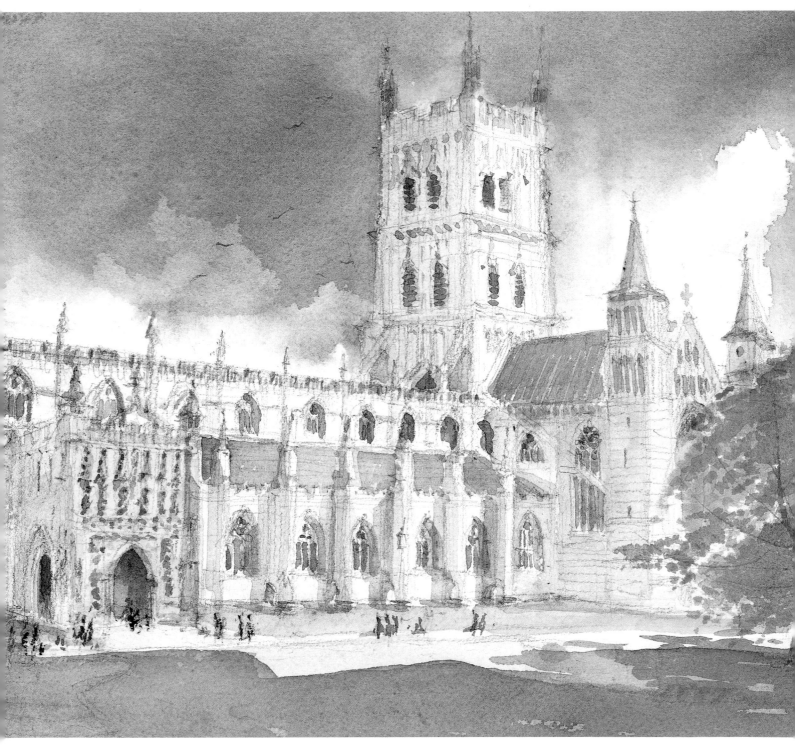

View from the south side

This compact, intimate example of medieval architecture has a complex building sequence but dates basically from the twelfth century. Standing on the banks of the River Wye and composed of pink sandstone that has crumbled over the years, it was much restored in the nineteenth century. But it is still crowned by its superb central crossing tower, richly adorned with pinnacles and ball-flower decoration particular to the Decorated style. Founded as a cathedral in 676, it is the home of the celebrated manuscript map known as the "Mappa Mundi" of about 1290 and also of the largest chained library in the world, containing volumes dating back to the eighth century.

In 1786 the whole of the west end of the cathedral fell, dragging down several bays of arches in the nave. James Wyatt was commissioned to rebuild, and after much demolition he reconstructed the façade and the entire nave above the original Norman piers. Today there is an arresting twentieth-century gold corona hung over the crossing sanctuary, which glows with light, contrasting with his solemn, dark stonework. Wyatt's west front was replaced in the nineteenth century, to a design by John Oldrid Scott.

When the architect Augustus Pugin visited Hereford Cathedral in 1833, he was inclined to be critical, showing how taste in church architecture can be controversial:

I rushed to the Cathedral; but horror! Dismay! The villain Wyatt had been there ... Need I say more? No! All that is vile, cunning and rascally is included in the term Wyatt ... In this church there is much to admire, a good deal to learn, and much to deplore.

FROM *RECOLLECTIONS OF A. PUGIN* BY B. FERRY (1861)

View from the north-west

HEREFORD

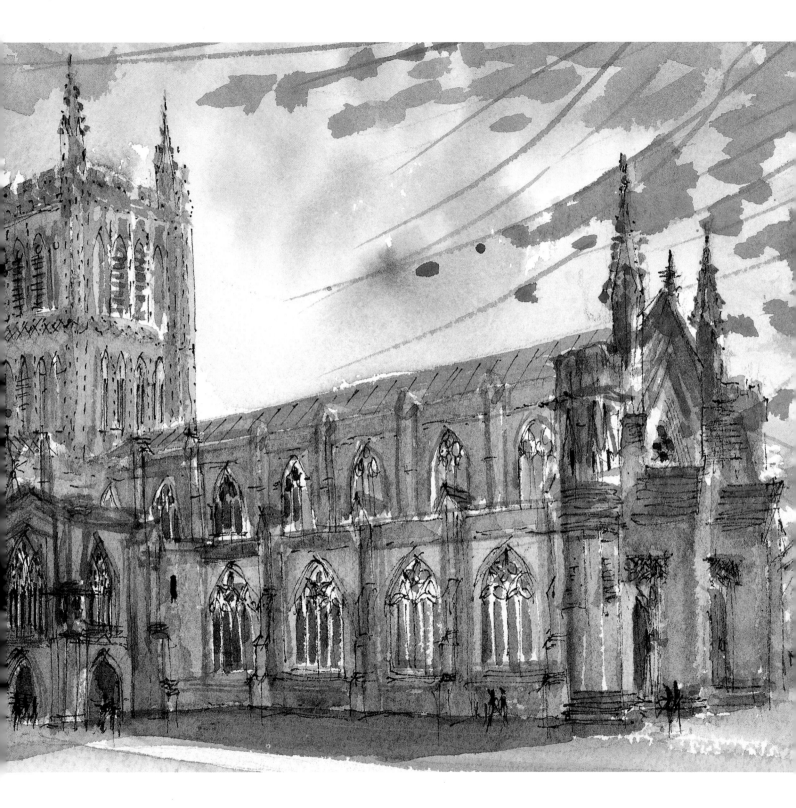

Worcester Cathedral is best seen from the river. It stands on a noble, commanding site above the eastern banks of the River Severn. Founded as a cathedral in 679, it has had a troubled history of fire and conflict. The exterior is massive and finely proportioned, built continuously from the eleventh to the fourteenth centuries. But twenty years of drastic restoration work, begun in 1855, following the decay of the soft sandstone, did little to enhance its character and texture. But soaring above is the gracious mid-fourteenth-century Perpendicular tower adorned with crocketed pinnacles, which gives the cathedral beauty and dignity.

My first impression of the interior is of harmony and the sensitive blend of different styles of renovation through the ages. There is a clear, uninterrupted view of the whole length of the cathedral, with the roof ridge visible from end to end.

The window dedicated to Sir Edward Elgar (1857-1934) is in the North aisle of the nave and depicts Gerontius held fast by the Angel. Cardinal Newman (1801-90) wrote a poem about the soul leaving the body at death, used by Elgar for his oratorio:

I went to sleep and now I am refreshed.
A strange refreshment: for I feel in me
An unexpected lightness, and a sense
Of freedom, as I were at length myself,
And ne'er had been before. How still it is!
I hear no more the busy beat of time,
No, nor my fluttering breath, nor struggling
pulse;
Nor does one moment differ from the rest.
Another marvel: someone has me fast
Within his ample palm.

"The Dream of Gerontius" (1865)

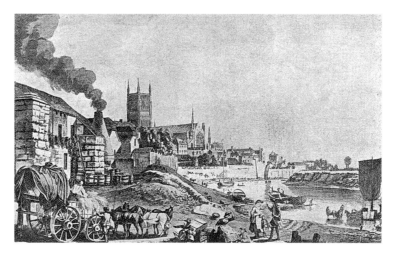

View of the cathedral, from an aquatint by Paul Sandby (1778)

WORCESTER

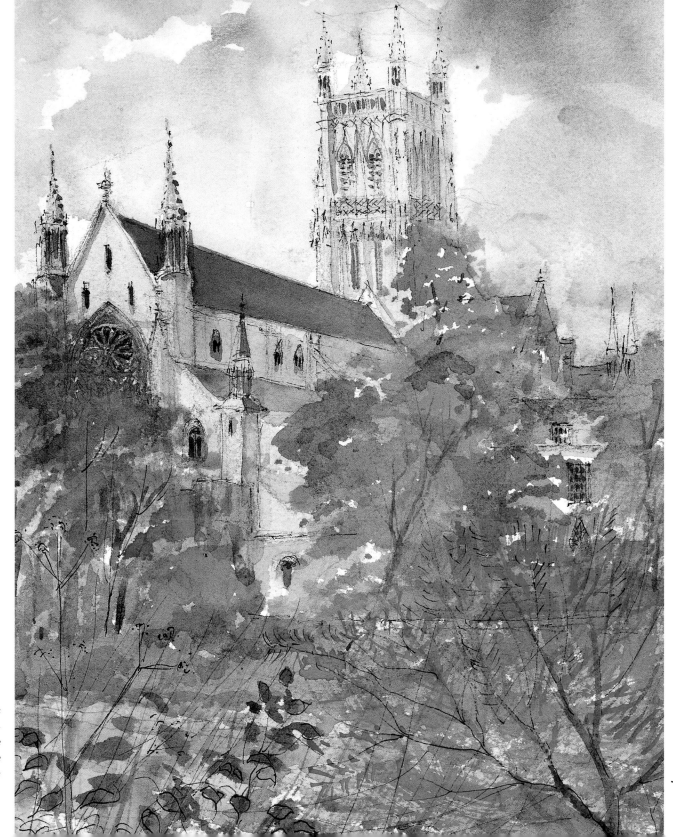

View from the south-west from the banks of the River Severn

35

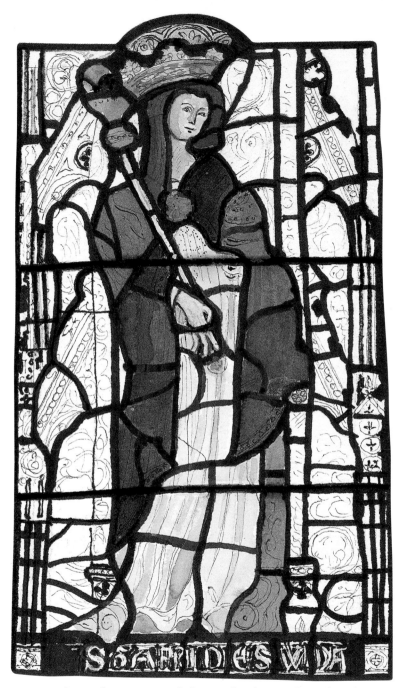

A fourteenth-century stained-glass window depicting St Frideswide

ngland's smallest cathedral is said to have been founded by St Frideswide, a Saxon princess, in 700 as a priory. It was rebuilt in 1158, but this Norman church lost four of the eight bays of its nave when Cardinal Wolsey laid out the large quadrangle of present-day Christ Church College in 1525. It was made a cathedral in 1542 and serves also as the college chapel.

The interior is vibrant with interest and beauty. I have tried to capture the contrast between the rich, dark carved wood of the choir stalls, set against the complex snowflake delicacy of the white, stone pendant lierne vaults. Light flows through the glowing stained glass set in the simple twin rounded arches behind the altar screen, and even more luminously through the jewel-like colours in the wheel window above.

Matthew Arnold (1822-88), Professor of Poetry in Oxford, wrote "Thyrsis", a song for one voice, to commemorate the death of his friend, Arthur Clough, in 1861:

That sweet city with her dreaming spires,
She needs not June for beauty's heightening
Lovely at all times she lies, lovely tonight!

OXFORD

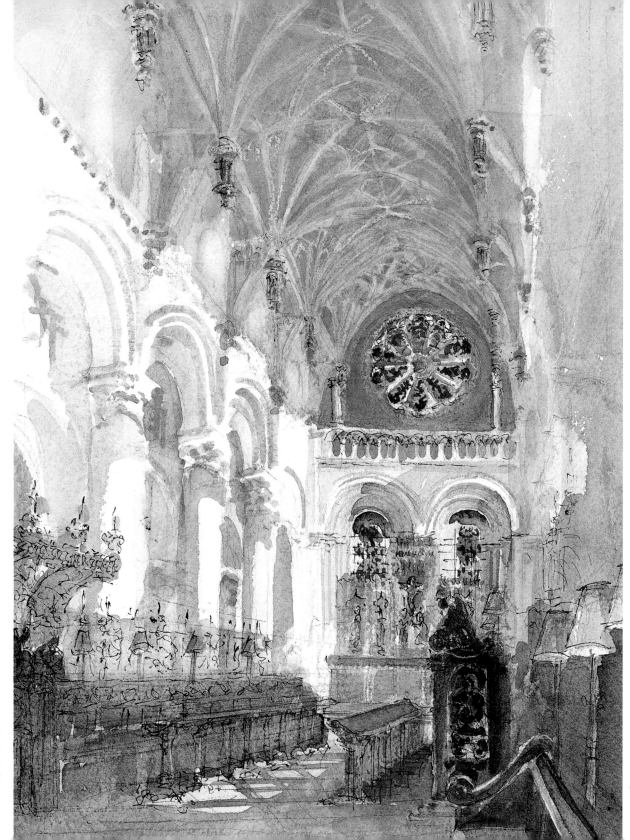

*View of the
interior from
the choir
looking towards
the east end*

37

St Albans Cathedral, a Saxon foundation of 793, was erected on the site of the execution of Alban, the first of England's Christian martyrs, in the Roman town of Verulamium. The present building was begun in 1077 but did not become a cathedral until 1877. Drastic restoration by the amateur architect Lord Grimthorpe, after the cathedral had fallen into a shocking state of disrepair, has left the exterior with little distinction apart from the Norman tower, built of dark red Roman brick. But the interior is imposing. The mixture of Norman and Gothic architecture is immediately apparent in Europe's second longest nave, where the thirteenth- and fourteenth-century wall paintings of the crucifixion on the wall piers are moving in their timeless simplicity.

I have tried to show how impressive are the Norman arches in the transepts, where the north rose window, set with contemporary glass, gives colour and contrast to their sombre grandeur.

This story of Alban is summarised from the work of the Venerable Bede (673-735):

Alban was a Roman soldier stationed in the once famous town of Verulamium. Although not a convert himself, he took pity on a Christian priest and sheltered him from persecution. The priest's devotion won him over to the new faith and when soldiers came to Alban's house, he changed clothes with the fugitive and he was taken away and condemned to die. He was beheaded about 300 AD on the hill where the cathedral now stands.

BEDE, *ECCLESIASTICAL HISTORY OF THE ENGLISH PEOPLE* (731)

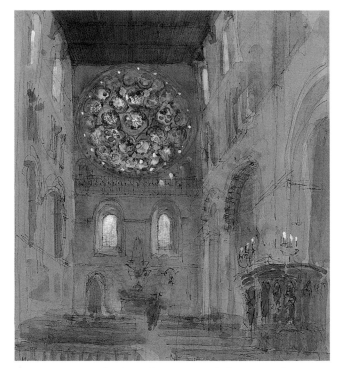

View towards the north transept and the rose window

View from the south-west to the cathedral on the hill

ST ALBANS

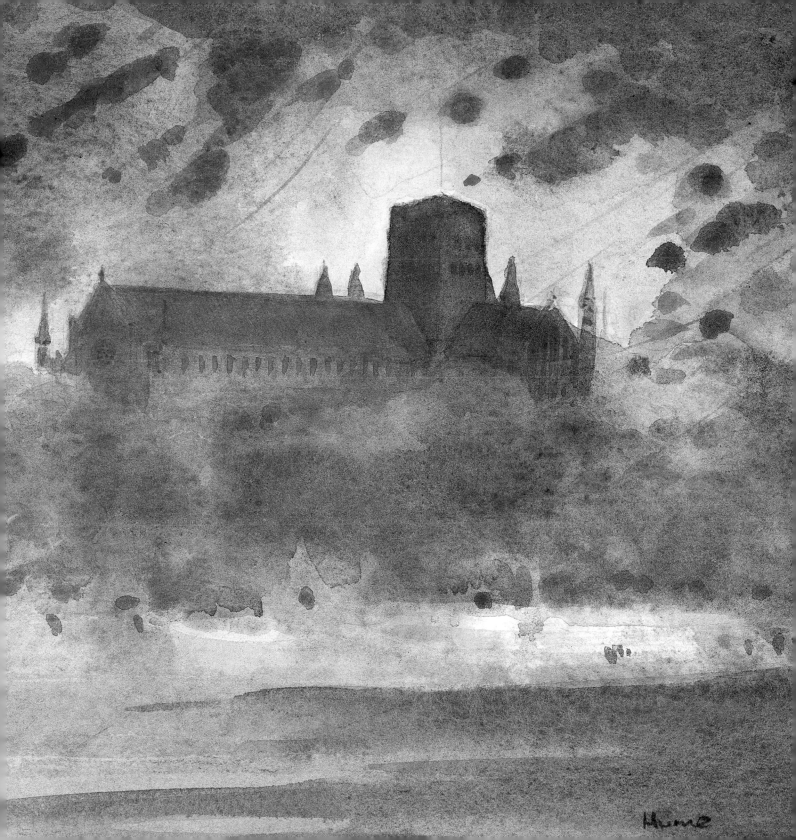

A monastery was founded here on the Isle of Ely, surrounded by impenetrable fenland, in 673. The present building was begun in 1083 and became a cathedral in 1109. Set in low-lying country where Hereward the Wake took refuge in his stand against William the Conqueror, this cathedral, 537 feet in length, appears like a great ship floating over the fens, which can be seen for miles around.

The main feature of the Norman nave, with its wooden ceiling painted in the nineteenth century, is the octagonal crossing at the transepts. When the crossing tower fell in 1322, a unique timber lantern tower was built which is a masterpiece of practical technical ingenuity. All England was searched for the timber to cut eight great oak beams 63 feet long and 3 feet square which were needed for the construction of this awe-inspiring design. Alan of Walsingham, who is said to have conceived and executed this architectural wonder, is an example of a medieval craftsman who possessed the qualities extolled by Vitruvius, a first-century AD Roman architect, who wrote in the only surviving classical treatise on architecture:

He who is theoretic as well as practical, is therefore doubly armed; able not only to prove the propriety of his design, but equally so to carry it into execution.

POLLIO VETRUVIUS, *DE ARCHITECTURA* (WRITTEN BEFORE AD 27)

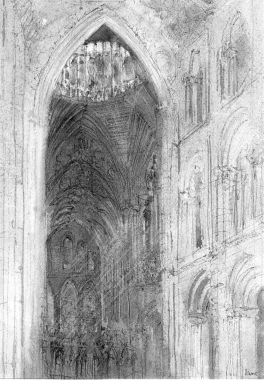

The nave looking east to the lantern crossing

ELY

The west front at night

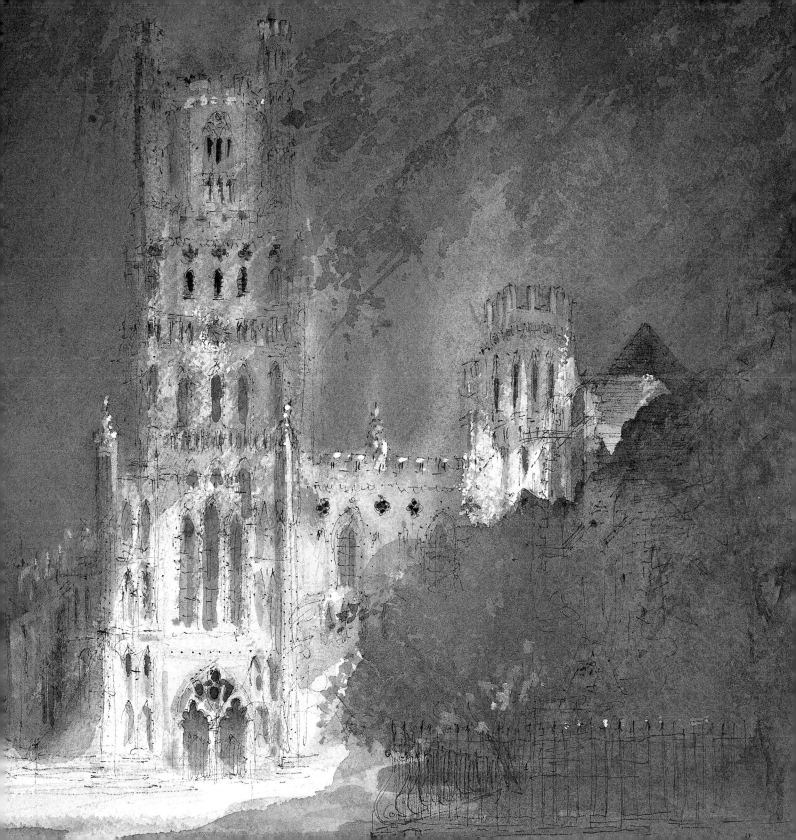

Peterborough is one of the least altered of England's great Norman churches.

The present building, begun in 1118, was created a cathedral by Henry VIII in 1541. The west front is astonishingly dramatic and theatrical, with its three immense Early English arches (placed in front of the old façade) which rise 81 feet on enormous piers. The towers at each end give the necessary structural support to these vast arches.

Within this Gothic proscenium, the fifteenth-century entrance porch, with the cathedral library above, leads into a magnificent three-tiered Norman nave with a painted wooden ceiling, which carries the viewer's eye through to the apsidal east end.

I had only half a day in Peterborough to complete my sketch of this unique building, and I wish I could have spent a longer time here in order to make a painting of the awe-inspiring interior.

Nurse Edith Cavell, who helped Belgian, French and British soldiers escape from Brussels in the First World War, spoke the words printed below before she was executed by the Germans in 1915. A memorial plaque was placed here, on a pillar in the south aisle of the nave, by teachers and pupils of her old school in Peterborough.

Standing, as I do, in the view of God and eternity I realize that patriotism is not enough. I must have no hatred or bitterness towards anyone.

An account from her attending chaplain, reported in *The Times* (October 1915)

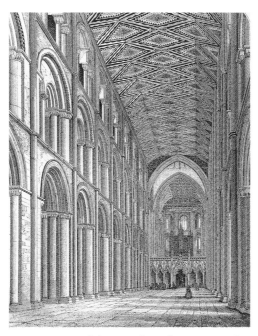

An engraving of the nave, from the west (c. 1862)

PETERBOROUGH

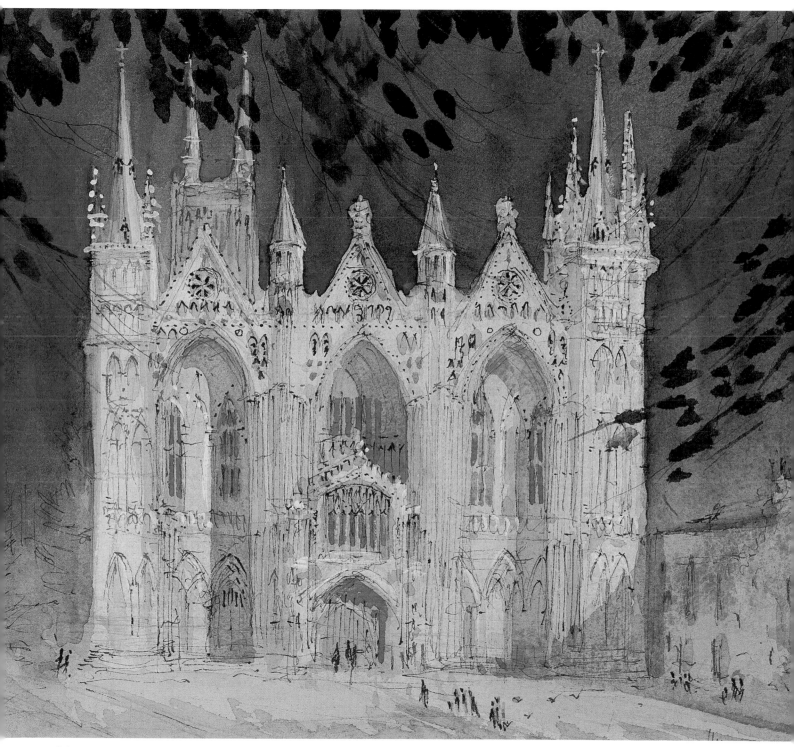

View of the west front

The spire of Norwich Cathedral, soaring in singular, pristine beauty to 315 feet, and the wing-like flying buttresses supporting the apse at the east end, give a wonderful light, elegant aspect to the exterior. The present building was begun in 1096, but the first church here, probably of timber, was built in 673.

This elegance is also reflected inside the building, with its graceful Perpendicular east windows that flood light on to the curved pink stone around the high altar. Sitting in the choir to paint, I tried to capture this flight of glowing colour. The interior is remarkably harmonious and ordered due to the completion of the building by the Normans in about fifty years. It has hardly been altered since, only enhanced by the later Perpendicular lierne vaults extending throughout the nave, transepts and presbytery. These were designed with such artistry that the ribs rise in easy, natural branches from the grand Norman structure.

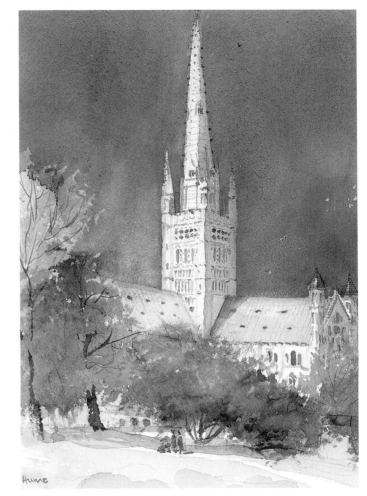

West view of the spire from the Close

Sir Thomas Browne (1605-82), who practised medicine in Norwich for forty-five years, wrote of his faith and deep spirituality:

Sure there is music even in the beauty, and the silent note which Cupid strikes, far sweeter than the sound of an instrument. For there is music where ever there is harmony, order, or proportion: and thus far we may maintain the music of the spheres.

FROM *RELIGIO MEDICI* (1635)

NORWICH

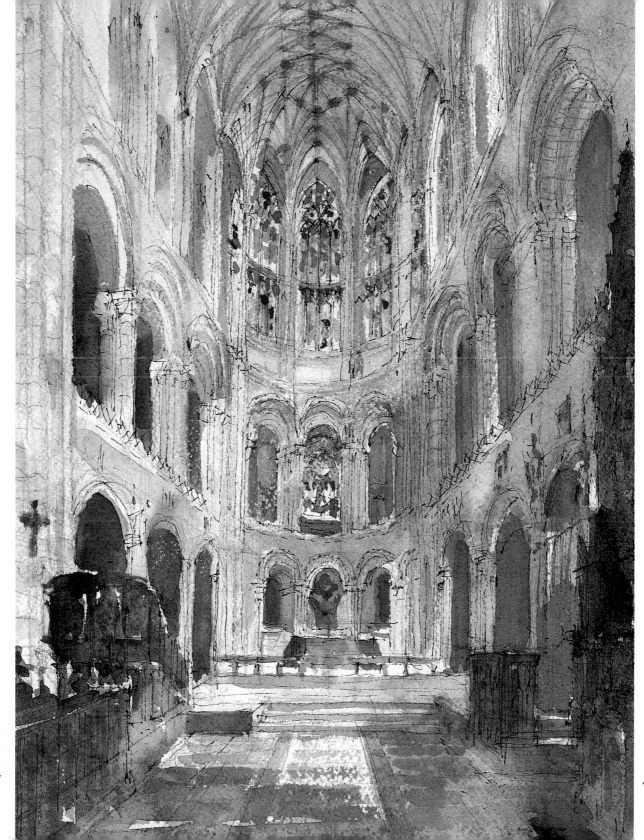

*View from the
choir looking
towards the
east end*

45

Lincoln Cathedral, visible for miles around, is perched high on a limestone ridge. It was founded in 953 and was established as a cathedral in 1072. Only the west front and west towers of the original Norman building survived an earthquake in 1185. The famous west front, with Romanesque carvings of beasts, birds, foliage and Bible scenes, was hidden by scaffolding and boards when I arrived to paint it, so I chose a view from the north side which shows the rose window, the Chapter House and the statue of Alfred Lord Tennyson (1809-92) who was born in the county.

The new cathedral building, begun by the Carthusian monk Bishop Hugh, is a masterpiece of Gothic, with its honey-coloured stonework and richly glowing stained glass. His asymmetrical choir vault is unlike any design found elsewhere. In 1256, only fifty years after its completion, St Hugh's apse was demolished to build the Decorated Angel choir, with its intricate, graceful carvings, to accommodate the many pilgrims to his shrine.

At the end of my day at Lincoln, I painted in the polygonal thirteenth-century Chapter House, which has a single, elegant central pier, a place of peace and calm.

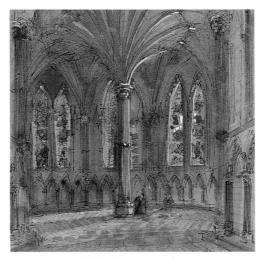

The Chapter House

The death of Tennyson's friend, Hallam, inspired his poem *In Memoriam*:

Ring out wild bells, to the wild sky,
The flying cloud, the frosty light:
The year is dying in the night;
Ring out, wild bells, and let him die.

Ring out the grief that saps the mind,
For those that here we see no more.
Ring out the feud of rich and poor,
Ring in redress to all mankind.

FROM *IN MEMORIAM* (1850)

View from the north

LINCOLN

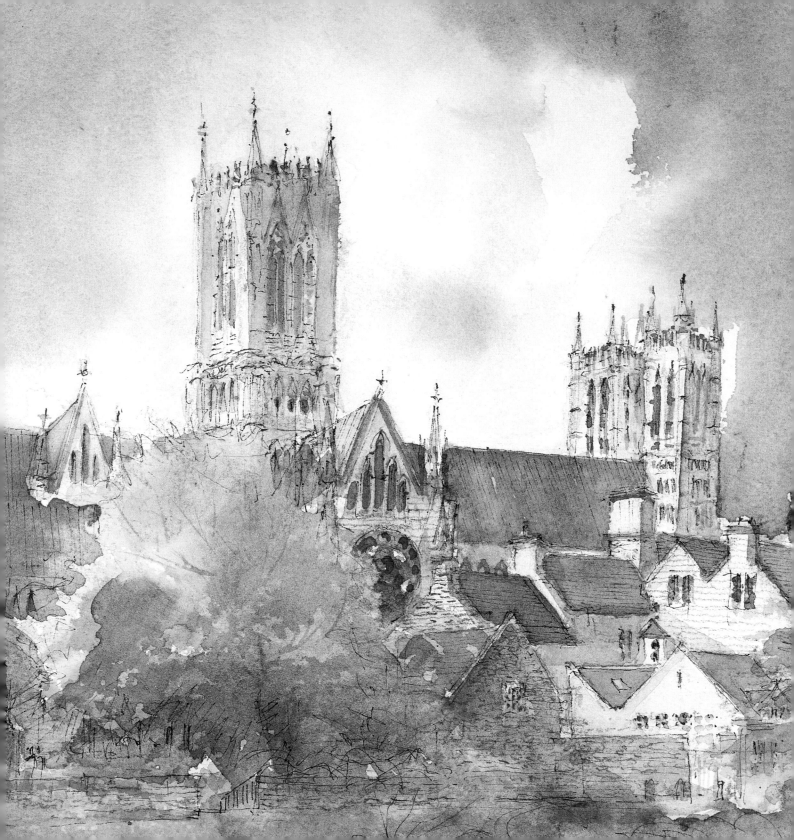

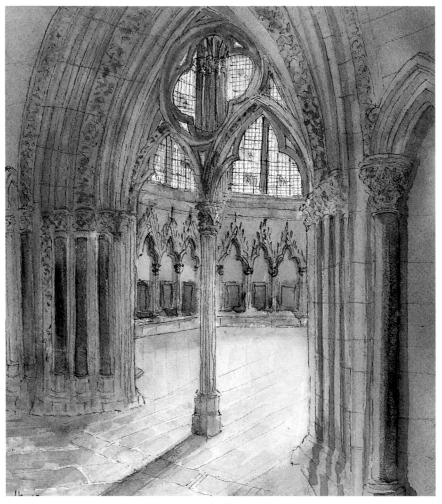

Entrance to the Chapter House

This simple, restrained cathedral reaches upwards in plain Norman dignity. Although Southwell Minster did not become the seat of a bishop until 1884, the present building was started in 1108. It still has its original towers, a handsome central one with interlacing arcading and two western towers, crowned by nineteenth-century stone spires, which are close in style to the originally intended Norman wooden structures.

Norman interiors were dark because of the small windows, like those in the nave, but later the lofty Perpendicular west window was inserted to let in more light. This window now has contemporary glass, designed by Patrick Reyntiens, depicting flights of angels with delicate, feathery wings like frost patterns.

The stone carvings in the small octagonal Chapter House are judged to be supreme examples of Middle Gothic artistry, inspired by nature's own beauty. The intricacy of the leaf sculpture encrusting the arches is echoed in the capitals of the columns; this acclaimed foliage in stone is known as the "Leaves of Southwell".

Be Thou praised, O Lord for our Sister, Mother Earth,
Who doth nourish us and ruleth over us,
And bringest forth divers fruit and bright flowers and herbs.

ST FRANCIS OF ASSISI (1181-1226)
"HYMN OF THE SUN"

View from the
north-west

SOUTHWELL

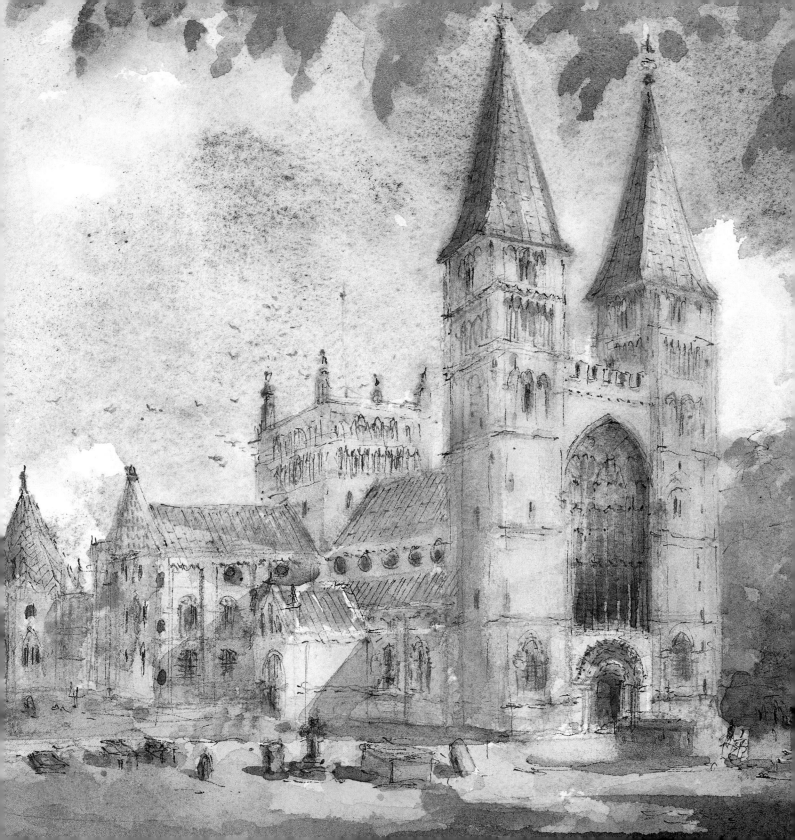

Founded in 700, the cathedral began as a Saxon church enshrining the remains of the seventh-century bishop and missionary St Chad. This cathedral, rebuilt 1195-1336, alone in England is graced by three spires, known as the "Ladies of the Vale", imposing a dramatic focus from all directions. Viewed from the peaceful Close, the elaborate west front, adorned with much Victorian sculpture, looks very theatrical. Its pink and blackened stone reminded me of some sinister illustration from *Grimm's Fairy Tales*.

By contrast, inside I was impressed by the cathedral's perfectly proportioned nave in the Early Decorated style, encrusted

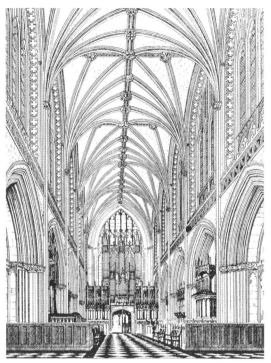

An engraving of the nave (1820)

by dog-tooth stonework in the triforium arches.

In the Civil War, Lichfield suffered more than any other cathedral in the land. Parliamentary troops shot away the spire, stripped lead from the roofs and wrecked images and stained glass. This is why so much of the building has had to be restored. But the Early English western part of the choir survives and the Perpendicular vaulting of the transepts gives the interior aspects of great elegance and character.

Samuel Johnson (1709-84), whose memorial was placed in the south transept in 1793, wrote an epitaph to a contemporary musician, Claudy Phillips:

Phillips! Whose touch harmonious could remove
The pangs of guilty pow'r, and hapless love,
Rest here distrest by poverty no more,
Find here that calm thou gav'st so oft before;
Sleep undisturb'd within this peaceful shrine,
Till angels wake thee with a note like thine.

"An Epitaph on Claudy Phillips, a Musician" (1740)

View from the
north-west

LICHFIELD

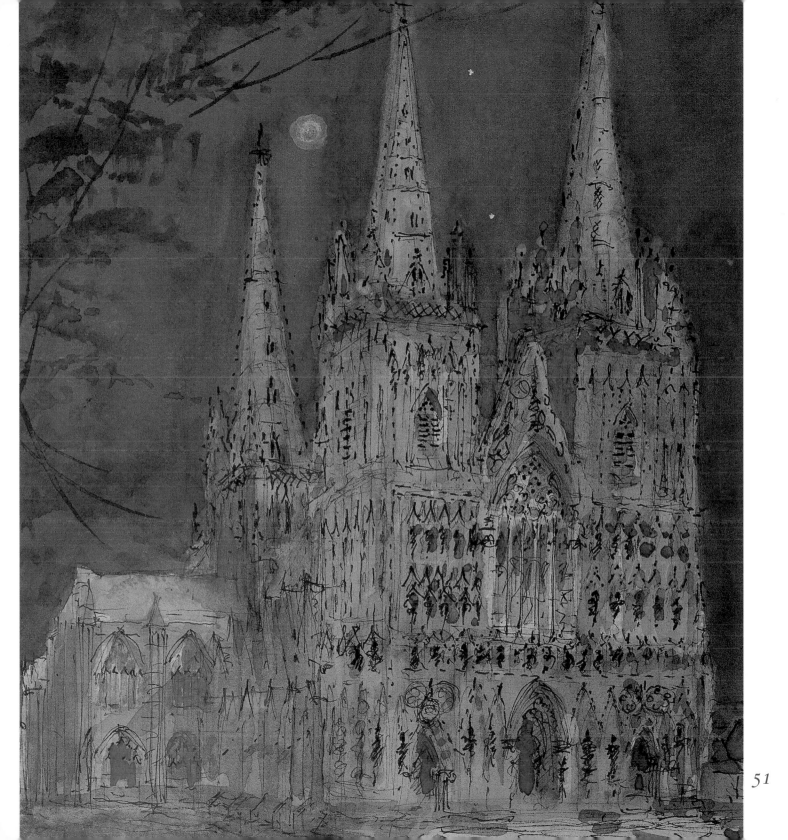

51

Chester was founded as the abbey of Benedictine monks in 1092 and was created a cathedral in 1541. The soft stone of the exterior required restoration in Victorian times. On the sunny day when I sat painting in the peaceful garden, the natural green patina on the cathedral walls seemed to glow, a striking contrast to the pink sandstone.

The joy of this building is inside. The fourteenth-century choir stalls display intricate and delicate wood carving. These and the misericords, depicting imaginative animals and dramatic human stories, are among the finest medieval woodwork in the country. Above the stalls are elaborate, richly worked filigree canopies. The pink sandstone gives warmth and colour to the rather severe nave, with its elegant nineteenth-century vaults.

Handel's oratorio, *The Messiah*, with words from the Old Testament, was first sung in Chester Cathedral before it was then performed in Dublin in 1792.

O thou that tellest good tidings to Zion get thee up into the high mountains. O thou that tellest good tidings to Jerusalem, lift up thy voice with strength; lift it up, be not afraid; say unto the cities of Judah, Behold your God ... Arise, shine for thy light is come, and the glory of the Lord is risen upon thee.
FROM "ISAIAH" 40 AND 60

View from the north-east

CHESTER

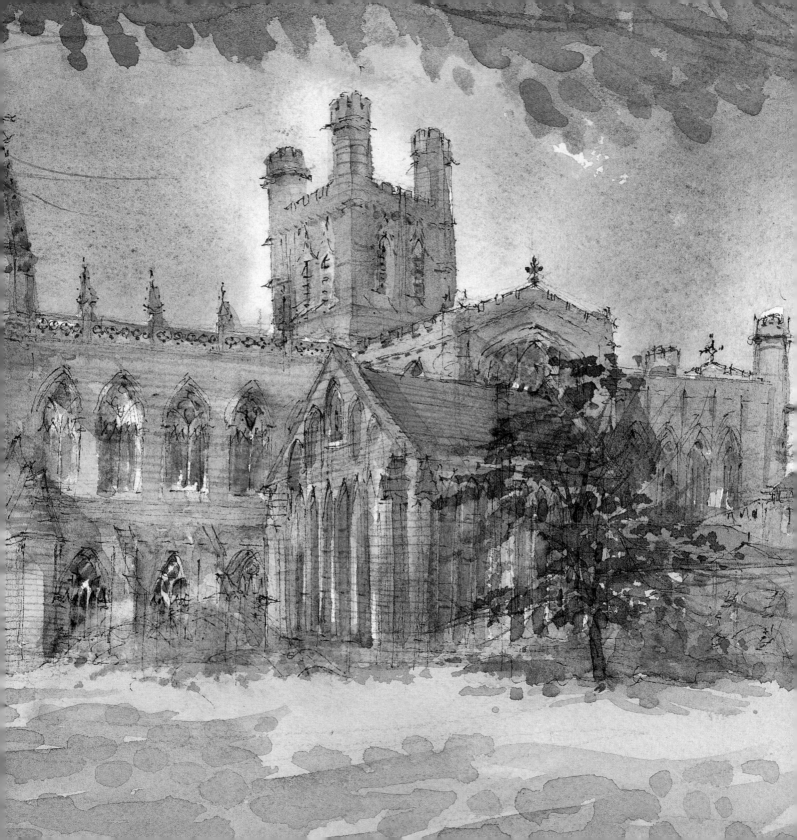

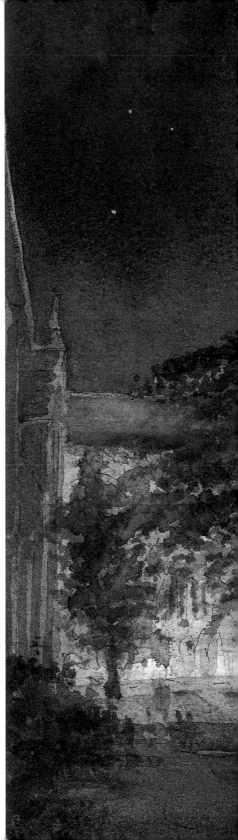

urham Cathedral is imposing and stately, sited high above the horse-shoe loop of the River Wear. To see it floodlit from the grounds at night is a dramatic experience which I have tried to record. It was founded as a cathedral about 997. The present building was completed in 1133 and took only forty years to build.

The interior is even more awe-inspiring. Its massive columns, incised with simple, bold designs, give a powerful image of Norman strength and domination, of a fortress as well as a shrine. This majestic building, with its original twelfth-century vaults over the nave and transept, is the finest example of Romanesque architecture in Europe.

The Venerable Bede (673-735), born near Durham and whose bones were finally laid to rest in the cathedral, wrote in *Lives of the Abbots* of the legend of St Cuthbert, whose shrine is also here:

St Cuthbert used to spend nights in prayer alone by the sea, often immersed up to his waist in icy water. On one such night "There came forth two beasts, vulgarly called otters, from the depth of the sea, which, stretched on the sand, began to warm his feet with their breath and busily wipe them dry with their hair."

View from the north-east at night

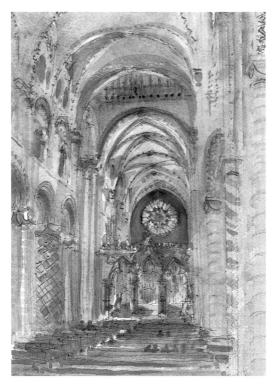

The nave looking towards the east window

DURHAM

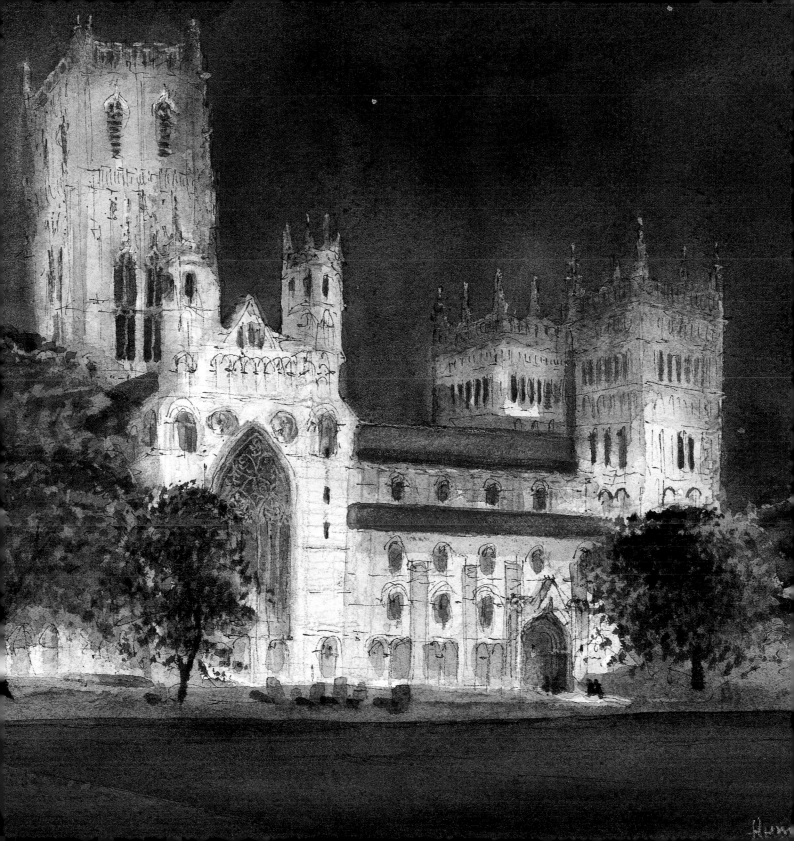

It was pouring with rain when I arrived at this border-city cathedral and started to paint in the shelter of a nearby covered logia attached to the Fratry. In spite of the damp I was able to enjoy its gentle, intimate aspect. It is the second smallest cathedral in England, following the demolition of six bays of the nave in the Civil War. An Augustinian priory was founded here in 1102 and it became a cathedral in 1133.

A quiet unassuming building, it has a surprisingly arresting interior. Its east end is lit by a fourteenth-century window which is said to have the most richly complex, curvilinear tracery in England. Memorable also is the panelled wagon-roof, which is painted blue, and adorned with glowing gold stars that immediately lifted my spirits as I entered by the south transept. This transept is the original Norman work, as is the remnant of the nave. Adding to the interest and quiet beauty of this cathedral are the early fifteenth-century, finely carved choir stalls and canopies. The elaborate wooden pinnacles were added later.

Sir Walter Scott (1771-1832), who was married in the cathedral in 1797, describes a Norman interior, such as Carlisle, in *Marmion* (1808), Canto ii:

In Saxon strength that abbey frown'd,
With massive arches broad and round,
That rose alternate, row on row,
On ponderous columns, short and low;
Built ere the art was known,
By pointed aisle, and shafted stalk
The arcades of an alley'd walk
To emulate in stone.

An engraving of the choir (c. 1869)

View from the south-west

CARLISLE

Very briefly, under the great Bishop Wilfrid of York (634-709), Ripon was a cathedral, and the present church contains elements that put it among the oldest Christian buildings in England. St Wilfrid's crypt remains, a rather sinister, secret place evocative of Christ's burial place and lit only by one candle – not a place to linger.

I liked the simple, austere, Early English west front, although it is rather ominous. But the south and east elevations are softened by a mixture of styles, including delightful gabled buttresses. These are best viewed from the informally landscaped garden on three sides of the cathedral. The turbulent history of this majestic church has meant that it did not regain its cathedral status until 1836.

The interior is an intriguing mixture of architectural styles from Norman to Perpendicular. The thirteenth-century east window is one of the finest examples of Geometric stone tracery in England, although the glass is nineteenth century. The choir stalls are mainly exquisite fifteenth-century work with curious misericords with mythical animals. These may have influenced Lewis Carroll (1832-98) in the making of the *Alice* books, because he attended here as a boy and knew the carvings well.

All in the golden afternoon
Full leisurely we glide;
For both our oars, with little skill
By little arms are plied...

Anon, to sudden silence won
In fancy they pursue
The dream-child moving through a land
Of wonders wild and new,
In friendly chat with bird or beast –
And half believe it true.

Thus grew the tale of Wonderland,
Thus slowly, one by one,
Its quaint events are hammered out
And now the tale is done.

FROM *ALICE IN WONDERLAND* (1865)

View from the north-west

RIPON

My visit to York Minster coincided with the unveiling of a fine new bronze sculpture outside the south transept of Constantine the Great, who was proclaimed Roman Emperor in York in 306.

This mighty building, founded as a cathedral in 627, began as a little wooden church where the first Archbishop of York was appointed. Though much restored – a continuous process throughout the centuries – the present building is magnificent. The great fifteenth-century tower rises in majestic simplicity, while the west front, with vast pinnacled towers, gives an imposing impression of strength.

I chose to paint the north side, which includes the fine octagonal Chapter House that has no central pier supporting the roof. This is a masterpiece of constructional design which retains much of its original early fourteenth-century glass. York has the widest Gothic nave in England (begun in 1291); it is a noble example of the Decorated style, with lofty clustered piers

supporting a wooden roof. The cathedral has immense windows flooding the spacious interior with light. The great east window, built in 1405-8, a vast curtain of brilliant colour, contains the world's largest area of medieval stained glass, set in tiers of fine tracery.

Albinus Alcuin (735-804), man of letters and teacher, born in York and educated in the Cloister School, wrote this prayer:

Eternal Light, shine in our hearts;
Eternal Goodness, deliver us from evil;
Eternal Power, be our support;
Eternal Wisdom, scatter the darkness of
our ignorance;
Eternal Pity, have mercy upon us.

PRINTED IN THE CATHEDRAL'S INFORMATION LEAFLET

Interior looking towards the Great East Window

YORK

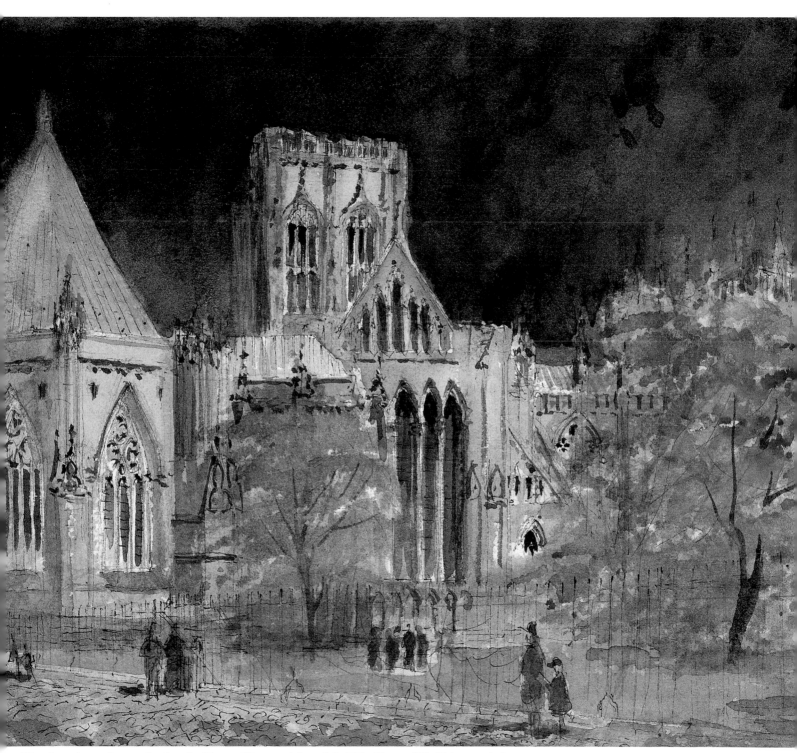

View from the north-east, showing the Chapter House and four of the "Five Sisters of York" lancet windows

EPILOGUE

Visions of all these wonderful buildings, each with its own distinctive character, will always stay in my mind. Their spectacular concept of design, their construction using rudimentary equipment, the breathtaking achievements of so many craftsmen gifted with innate skill and sensitivity in their use of wood, stone, wrought iron and stained glass, all these elements culminate in each cathedral to create a moving spiritual experience.

Many of these cathedrals are undergoing extensive renovation, and it was not always possible to paint the views I would have preferred, but they must be carefully maintained if they are to survive in the new millennium.

I began this pilgrimage in Canterbury and ended it in the Lady Chapel at York Minster, painting the Great East Window. It was the completion of a long, hard journey, and yet I was sad it was over. My final thoughts are perfectly reflected by Milton.

But let my due feet never fail,
To walk the studious cloisters pale,
And love the high embowèd roof
With antick pillars massy proof,
And storeyed windows richly dight,
Casting a dim religious light.
There let the pealing organ blow,
To the full voiced choir below,
In service high and anthems clear,
As may with sweetness, through mine ear,
Dissolve me into ecstasies,
And bring all heaven before mine eyes.

JOHN MILTON (1608-74), *IL PENSEROSO*

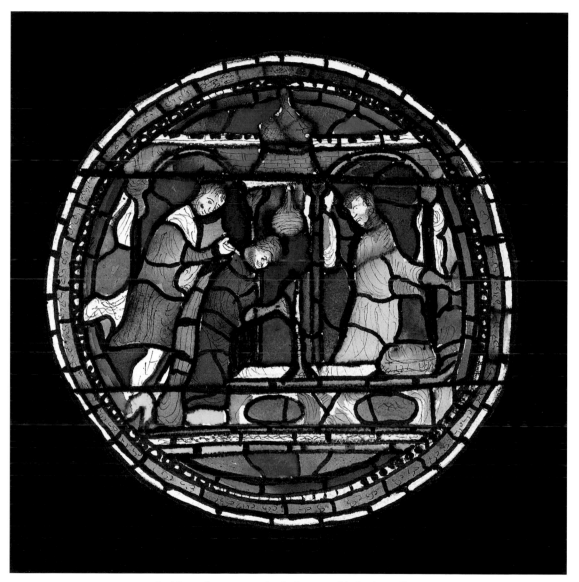

*A thirteenth-century stained-glass roundel showing pilgrims
at Thomas à Becket's tomb. Canterbury Cathedral*

ACKNOWLEGEMENTS

The author and publishers are grateful to the following for their kind permission to paint the cathedrals, and to reproduce the paintings in this book:

The Dean and Chapter of Canterbury
The Comptroller of Rochester Cathedral
The Provost of Southwark Cathedral
The Dean and Chapter of Winchester
The Dean of Chichester
The Dean of Salisbury
The Dean and Chapter of the Cathedral Church of Saint Peter in Exeter
The Dean and Chapter of the Cathedral Church of St Andrew in Wells
The Rector of Bath Abbey
The Dean of Bristol
The Dean and Chapter of Gloucester
The Dean and Chapter of the Church of the Blessed Virgin Mary and St Ethelbert in Hereford
The Dean and Chapter of Worcester
The Dean and Canons of Christ Church Cathedral, Oxford
The Cathedral and Abbey Church of Saint Alban
The Dean and Chapter of Ely
The Dean and Chapter of Peterborough Cathedral
The Dean and Chapter of Norwich Cathedral
The Dean and Chapter of Lincoln
The Provost of Southwell Minster
The Dean and Chapter of Lichfield
The Dean and Chapter of Chester Cathedral
The Dean and Chapter of Durham
The Dean of Carlisle
The Dean of Ripon
The Dean and Chapter of York Minster
The author would also like to thank all the church guides for their valuable assistance, and Adam Tolner for his superb photographs of all his paintings.

FURTHER READING

Blair, John, *The Cathedrals of England* (Gilmour and Dean, 1971)
Clifton-Taylor, Alec, *The Cathedrals of England,* World of Art (Thames & Hudson, 1989)
Darracott, Joseph, *England's Constable* (Folio Society, 1985)
Fletcher, Banister, *A History of Architecture, on the Comparative Method,* 13th Edition (B T Batsford Ltd, 1946)
Johnson, Paul, *British Cathedrals* (Weidenfeld & Nicolson, 1980)
Little, Brian, *English Cathedrals* (B T Batsford, 1972)
New, Anthony, *The Observer Book of Cathedrals* (Frederick Warne & Co Ltd, 1972)
Pepin, David, *Discovering Cathedrals,* 6th Edition (Shire Publications, 1994)
Pitkin Guides to the Cathedrals (Pitkin Pictorials)
Tatton-Brown, Tim, *Great Cathedrals of Britain* (BBC Books, 1989)

PHOTOGRAPHIC REPRODUCTION

Adam Tolner, 10A Printing House Yard, Hackney Road, London E2 7PR

Distributed in the USA and Canada by Antique Collectors' Club, Market Street Industrial Park, Wappingers' Falls, New York, NY 12590

ISBN 1 85759 221 2

Designed by Peter Ling
Edited by Moira Johnston
Printed and bound in Italy by Artegrafica s.p.a., Verona